FLOWERS OF POESY

FLOWERS OF POESY

Eighth Day

DANY M HATEM

My dearest Abby,
Wishing you all the
very best in life.
Chase your dreams;
Embrace the journey!
Lots of Love,
Dany xxx

Dany M Hatem

For Marc, Yves, and Christian,
the loves of my life.

Contents

THE OTHER SIDE

A LIFE AT SEA

TEMPTATION

LADY SKY

MY WEALTH

LOST IN TRANSLATION

Lost is a place
From all walks, they come
The free, the willing, the outcast:
All find lodging.

Familiarity with the strange
Comforts those who exist in the bleakness
Between life, not quite lived
And love, unrequited.
Their expression: lost in translation.

Lost becomes an anchor to belonging
Somewhere
That's neither here nor there.

SEARCH

We search every face
Until we find the one
Which is the only one we've seen

Then, we search some more
Until we find ourselves
In what in us they see.

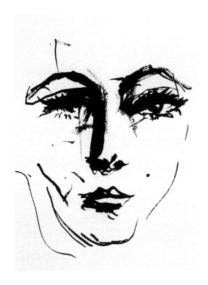

ALLEYWAY PHILOSOPHY

I found truth in the narrowest of places
the dark, deserted alleys of life. Where
Silence deafens and the Self
Screams to be heard.

And, it has made all the difference.

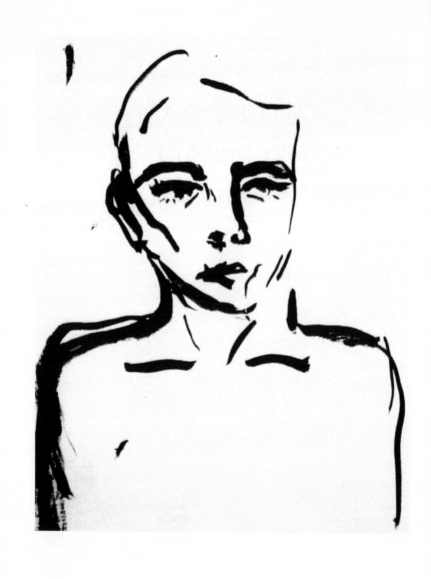

4 AM

Be still. Observe for a while. Do not partake. Be silent. Breathe.
Rest if you must. Close your eyes. Let peace find you. Let go.
Clear your mind. Leave your heart alone a while – it will keep
beating; let it revive. Forgive yourself, first. Let the world go on
at its pace, for once; slow yours down. Be proud that you do not
jest with the hearts and minds of others. If you've stumbled, do
not lose heart. Stones can be removed. What is broken, heals.
Do not gather the scattered pieces: they were meant for the
wind. Trust that your heart and mind have the power to renew.
If your intentions were good and you were defeated, let it go;
the Universe knows what you set out for. Count your blessings;
appreciate each one. Accept disappointments. Learn from those
around you; you shan't live long enough to learn every lesson for
yourself. Stay humble in a pretentious world. Though you
doubted your instincts before, trust them now; they are body-
guards of the soul. Release yourself from dependency: stand, do
not be held. Stay close to the Earth, its wonders surpass every
new wonder society coins. This world owes you nothing, though
it offers you all. You are worthy of another chance. You will be-
gin again, not in a new house, but when your heart is still. The
Earth sleeps then wakes to the Sun. Listen. Learn. Be still.

ADOREMUS IN AETURNUM

The artist searches the universe for
The one to make immortal
Only to one day perish beneath the weight of its craft.

DOCK

You believe you've seen the world
For having sailed round it many times
You believe you know its people
For having greeted them at every port
You believe you know freedom
For having bathed in the salt of every sea
You believe you know love
For having sailed through golden waters of a melting sun.

That morning, the wind hushed
Slowed your journey
Lowering your sails, you let calm waters lead
The hull of your boat drew close enough
To consummately fit the palm of my hand
Battered ribs expanded against receptive flesh
So emerged unmapped coordinates.

You had not known you could speak without voice
Or that the silent sun could sing
Or that beneath your counterfeit euphoria, the surface you
skim

The waters, mountains, the shallow smiles
Lies true nature
Hard truths and
Beauty so exquisite, its effect is to
Rewrite your charts
Make irrelevant your traveled course
Baptise you in true religion.

You stepped off a swaying deck
To walk virgin valleys, fields of bloom
To lay upon a firm, cradled earth.
When you tasted the smallest token of a humble heart
You became a student to the poet, and
Poet found a muse.

CAUTION

Should the soles of your feet
Meet the fate of hot coals
It is then
You shall feel frailty.

Notice scattered, fallen leaves that once withstood storms
Smell sweet perfume of flowers in the spring
Behold a silent wish ride the breeze upon dandelion seeds
Evade capture by silken-spun webs.
Dream of flight upon ethereal wings of butterflies
Hold the sky in your hands through a fallen bird feather
Walk through morning mist as though through a dream
Catch snowflakes on lashes, face to the sun
Pause...to ponder the romance of a rainbow
Search photographs for lost moments now ached for
Glimpse tears pooling in the corners of a lover's eyes...

None
More delicate than
My wounded heart.
Tread carefully.

ESSENCE

Sun on my face, I walked down a big city street
As you, collar up, walked along its shaded side
Had our eyes met...

I left my table, as you sat down to yours
I stood on the cliff edge, watched dying embers of a fading sun
You walked below, footsteps dissolving along a sandy shore.
I cried inside to put out the spark of my relentlessly searching
soul
As you tired, trying to find embrace behind a lover's eyes.
I dreamt of you wide awake as you slept
Twisted in limbs, doubting my existence.
I wrote to you the hushed poesy of my timid heart
And you, the chords no sullied voice would spoil.

I journeyed many miles of this short life
Collecting memories with black spots.
Like a leopard, you sped through your years
Arriving first to the place where time stands still - downwind
Where you had caught my scent, halted
Then, waited for me to catch up.

TWO

My love, we are good together
But we will always be two.

We've caught each other's spark
But we won't be one flame
Two pillars, not one stone
Two instruments playing the same song
Two seasons, one following the other
I, the night
You, the morrow
One the Poet, the other, Muse
One, the hat, the other, shoes
We're not the same weather
We're not the same storm.

Write music in my name
I'll give them words, the same
Dare to dream, to fly
Brand your name across the sky
See the birds, aged trees
How sky touched their leaves

Armour for your wings, I bestow
Knowledge of my years
A home inside your own
For the bird who flies
Makes a nest upon weathered boughs.

POETIC STUTTER

Kiss the Earth
Touch the sky
Enjoy freedom, fly.
Sail the oceans
Frolic in fields
Only to thy own heart, yield.
Chase shooting stars
Sleep upon clouds
Deafen your foes – live so loud.
Bask in the glory
Steal glow from the moon
Leave them wanting – gone too soon.
Experience the phenomena of the migrating Monarch's
Eat of the sweetest honey made by Queen's
Adorn yourself with buried treasures, once lost in deep, dark
seas.
Streak boldly through delicate pastel colours
Drink hot tears of an angry Sun
Break one thousand hearts into a million pieces, all of it for
fun...
Only, keep coming back to me.

ONCE UPON A ZEPHYR

A melody swept in upon a wind
Lonely words rose to embrace their kin
Flowers bloomed, swayed along in dance
Blessed to have the chance.

Even the moon appears to steal a look
At a love born when two worlds shook
You stole the stars and brought them down
To place upon my gown.

Instead of a body by lust defiled
Lost innocence of a child
Should light your eyes, beckon a dove
A poet's love.

Instead of these dark, hollow streets
Flowered, sunlit path, for you, I seek
To warm the wings that Zephyr meets
World at your feet.

I would that you could feel my throbbing heart
Rather than tread the seven seas keeping us apart
Buried in the lesser world you'd find
We leave the rest behind.

With longing, you gaze into crowds of faces
Where some notion of love may have left traces
Alas, I haven't the wings to fly
To be by your side.

Books pass stories between their covers
Pages blanket the passion of lovers
Same play gracing so many stages
Of bygone ages.

FALLEN ANGEL

I'd drink salty tears, drain all the oceans
If it would bring you near. I'd voyage
Across deserts
To hold you.

Only, let the rain fall, let the
Depraved sun burn your haste
Listen to the laments of the moon
Upon each stir of the wind
So you may know a new rhythm
To beat deep in your chest.

Patience, Love, patience
Let your hysteria sleep
Be composed. Arrest your pain
Bide the time you're reluctant to keep.
They did not conquer you, Beloved
Your wings torn, you were robbed
Of wind and
Cast from heights that once
Cradled you

For your divine sin
You are cast down and sullied.

But when I come, I'll smooth
Each ruffled feather; I'll mend
You, place you on a gale again.

Fly over your dominion; see
Inside the obscurity of your descent
In your wake, sailing unspoiled oceans
I'll pray you'll live each moment spent
Fallen angel.

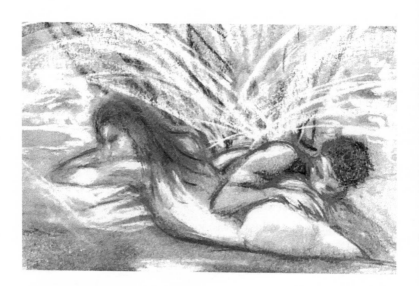

OF THOSE WHO DREAM

If I love you
Then, I love you
No grand declaration needed
For its rarity is vow
Enough.

I LOVE YOUR FACE

Beneath your jaw, beside your ear
Is where I lay my kisses down
And watch the Earth eclipse the universe.

Awestruck poets spill ink
Pay homage, to beauty
As sun and moon get their moment
Consuming the Earth
Their clandestine meeting
Seizing upon an aperture
When the cosmos feigns sleep
To shield passion
From those who do not believe.
And your eyes, my world
Turn black
Stars align
Lids close
Eclipse.

BOUNDLESS

I'll see him free, happy
I'll see him unbound again
Ascending. He will follow me
In my shine, in my wake
I leave him rippled delight
I give him my love to enjoy
So he may know in this life
As in past lives, joy no man has known.

That which shines upon me
May it also upon him
Boundless, inverse sea
I am a bird, he, my flock
We, our love and dreams.

CONTRARY

I thought perhaps Life's burn would forsake me
If I stayed in the shade of your lashes
Fused to your lips
Inside your lungs
Beneath your body...

Gently, I shed you of the skin they had touched
Took for granted
Defiled
To kiss you beneath
Inside
Traced throbbing veins with brushstrokes of fingertips
Lay my breast upon your warm, beating heart
Rested my ear against your temple
To hear the oratory of your thinking

And you cradled me
Whispering song of angels into my mouth.

What shall we do when all choices divide us?
Where can we go that ignorance can't find us?

How shall we live far from home in each other's arms?
Who shall we meet able to fill divine absence?
When, all we need, desire
Are our two souls, on fire.

I wonder if the rain cries anguished tears
For staying far from a forlorn desert
By what ancient duel was it cast away?
And yet, torn
Risks the wrath of lightning and thunder
For just one day
To feel the desire of burning earth
Rather than the loss to a gluttonous ocean.

LIGHT

No sun may scorch
Nor snowfall cloak
No bloom steal the beauty of
Love released from within Autumn's wisdom
When virgin sunrise
Weds setting passion
And two souls paint the world with light.

A TALE OF TWO CITIES

Somewhere between two cities
Lies a place
Inside a song, within a story
Where I renew my strength
An oasis of love
Inside a man.

You will see me arrive dying
And leave it living.

SECTION TWO

HOW SHALL I LOVE THEE?

Silence falls
No breeze breathes, no leaves
Stir. I open my eyes
And a wind gusts
As the world begins to play...

Shall I love you as the wind loves me?
A voice that travels from a mouth that I cannot kiss
Fingers that stroke but cannot be held.

Like the right hand of David
A zephyr finds its way into my hair
Grips my neck, shoots chills down
My spine travels my skin
Lust lifts a hem
So I may know he lies in wait...

And when I stay away too long
He howls in lonesome agony

He beats against my door
He fells trees in his despair
Urging me to remain far
Desperate for me to answer his need
Lest I forget him to human dreams.

In my dreams, seasons change upon his breath
Where storm clouds are sent away in haste.
At dawn, I emerge, and he falls silent
Kisses the backs of my hands and runs
Fingers through my hair.
Shall I love thee as I am loved by the wind?

IMPOSSIBLE

On rare occasion
Like a teenager making the most of her time before curfew
The moon would arrive early to observe the sun in all its splendour
Only to be invisible, muted
As the sky transforms into a canvas
Tortured artist bleeding onto the blue
Spurting rust on a once-new day
Painting furiously with the sudden arousal of passion
Even as it drifts toward sleep...
Its last vision: a speechless moon.

Her moon heart burns blue
Impossible lovers
Love at first sight, the ache of the last glimpse
No story in between
Courses never converging
Soft, fading whispers at night
Warm breath at dawn
And an unyielding faith in love
Nourishment in times of absence.

BELLA

Like an army moving furtively
Undercover of a starless night
Rain charged, fell heavily
Armour glittered beneath the moonlight.

As battle engaged, armies clashed
Earth drowned in the relentless downpour
I stood atop battered land, saw you approach
Without knowledge, I was to be fought for.

I have but little to offer
An infant plant buried beneath Winter's snow
Though, should it survive the bitter onslaught
It is yours with the bloom of my rose.

My rose birthed you a garden
Each petal, worshipped, you gave a name
I, since, born with each day's sun
Get to love you all over again.

OBEDIENCE

Conformity knows no revolt like that of a disobedient heart.

Reluctant dawn crept
Implored even the birds not sing
Mocking as her entrance was
Wearing radiance regretfully
Still, she rose
Upon the day
Which bade the lovers farewell.

INCUBUS

Precise, on target, pierce of your arrow
Found the beating scrap of my dropped heart
All over me with teeth like a harrow
Refusing toil and eager to start.

You set ablaze my temple of worship
Walked through fire to embrace your mirrored soul
You, rebel to whom I've no resistance
As Alice's fated fall down the hole.

As a harlot mocks love without shame
As the broken thrill to inflict pain
As the false mighty rise up to reign
A curse on your house, your heart, your name!

I beseeched the heavens to come smite me
With rage to set my heart free from you
But alas, angels gathered my fragments
Wordless hymn sounded, souls wed, love grew.

OPERA OF THE CLOUDS

As the dream-filled cloud
Seeks the ocean, lake, and puddle
To catch glimpse of its common beauty
You may chase the sun
Enjoy the kiss of sun-drenched days
Though, you shall live them through colourblind eyes.

You pass life a forged season, mute of birdsong
Observing of the cryptic night
Although, not privy to her revelations.

Darkness descends upon Earth's reverie.
Stargazers and theatergoers scurry
To behold wonders they do not understand
On stages, they'll never play
In their attempt to be a little less ordinary.

An obscure dancer struts onto the dais
Sways her form in flirtation

Backlit, resplendent in silver trim
Sheds layers revealing pale moon skin
A common cloud with a rebel heart
And the pull of celestial strings
Playing spirited games in a moonbeam playground
Amongst the glow of ancient bones
A nuisance to the astronomer
Dancer to the musician
The mystery to the painter
Ink to the poet.

Here, is where the artist roams
To escape the blinding light which tortures sleep-deprived irises
Where, upon a moonlit stage
Life plays more true
There, I am.

One awesome day
Silence breaks
Spring arrives to sow a bloom
Of realisation
Beneath the soiled facade of a smile...

From then
You shall search for me in every night sky
For the Rubenesque reds, I once painted your heart
For the Turner skies, I lent your days
And in desperate thirst for the
Immortality you tasted upon my tongue
Except

The final curtain shall fall
Night after night
Upon your unanswered anguish.

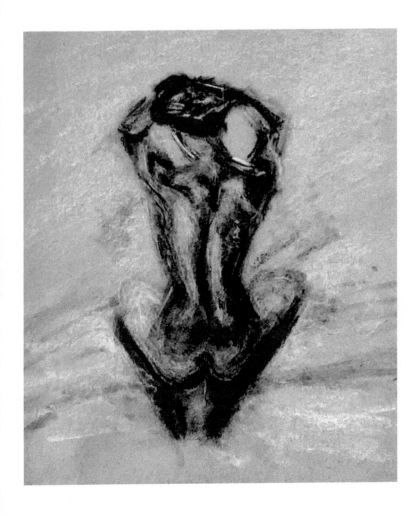

SEVENTEEN

I tried to sew my feet to your shadow
Only to strip colour from Spring
Our song made a dance of reluctant retreat
Where we stumbled
Stepped awkwardly
Hurt one another.

We should have kept on about-face
To meet once again at six o'clock
Instead, song hushed, we counted steps
Turned
You drew
Pierced
I fell.

You've vanished
I pay homage to a dream that was
I cry tears into the ocean
To keep you afloat
I bleed onto paper
To keep me.

THE
INTERPRETATION
OF DREAMS

It broke that night
When even my treacherous dream
Refused to paint you perfectly.

Unkempt and dimmed
Not a spark in your once luminous eyes
You filled my night visions with
The thick air of conceit
Insulted a well fought for peacetime
Invaded my thoughts with a pitiful army of unwelcome guests
Desecrated a place of worship
In a stunning exhibition of nonchalance.

Then
From such a height
You fell from grace
Becoming your own antidote.

NEVER AGAIN

You are the sun of a Spring I had never known
Bringing forth new life
Showering light upon the dormant matter
Awakening Wild from slumber
Caressing flower buds into flourishing form
Birthing infants into new worlds
They suckle from mythical beasts
And I frolicked in virgin fields
Felt sun kiss my pale skin
Felt life bloom from within, so ripe with passion.

Now, I yearn for summer
I want its burn
It's hot breath on my shimmering skin
Storm-broken, balmy evenings of foreplay
Sticky nights that keep me awake
Its pre-dawn agony, wrestling the lead weight of thin sheets
Cold showers, the water steaming upon the touch of a flaming body
Heat which turns your memory to ash...

So that you may drift
Upon winds
Far from where I am
Toward places, I shall never again go
So I may never again see or ever again feel
A whisper of Spring, the season I love
Which now, I shun forevermore.

HELLO

Before Spring turned barren
Before your freezing lash
Before a taciturn tongue obliterated poesy

Before descent, thorn by thorn
Before discarded memories
Before Forever feigned existence

Before making love to love itself
Before kisses lent colour to cheeks
Before disciple turned sage

Before she scattered glitter across your skies
Before your crooked smile knocked her off-axis
Before she stumbled, tripped and fell

Before
With no intention to
Love in return
You should never have said
Hello.

FADE

Just as your scarf loses your scent
With the passing days
How shall I bear more of you gone?

LOYAL MOON

The artist creates beauty, though his soul is tortured
The seamstress mends clothes, though her hands are stiff
The labourer toils for hours, though his back is almost broken

And, I would nurture and carry you
Though it tore me down, my silent agony
You became somewhat whole
I, damaged.

You couldn't see the colours of Spring I painted
Patches I sewed
Bridges I built
Rather, only saw me now flawed
A reminder of the past that drowned your light.

DELUSION

Burned by treacherous salt
I jumped land to escape your ocean
You keep throwing stones in hopes the ripples
Break rim.

Echoes of us ride the seasons
Piquant zephyr jeers at my sight
Your ghost seeks me like a hawk its prey
Blurred, deprived of clarity
I am easy game.
Swift and vicious, talons slash
Disturb the surface of fanciful serenity.

I dive deep, a willing wreck
Leaving trembling waters stripped of counterfeit mask
Relishing in your effect
You retreat in satisfaction, knowing
You've not been forgotten.

No waters run deep enough, no distance be far enough
To expel your existence from the breath of my lungs.

CONSUMED

Like that which burns
Between the thighs of the Earth
We are fire

Blazing love
A beacon to the lost
We are consumed

Carried away, scattered
This is how stardust becomes.

HUNGER

I put the vowels in your prepubescent alphabet
I made you sing
I was the lost wonder of your youth
I filled your eyes
I was the desperate dream you couldn't have
I came by day
I shone, but not as bright
Shadow of the wish of night

You loved me for all you had not
And led me where my God was not

I flew without wind
Nudged you forth though I tired
To live up to your stolen dream.

SMOKE

Surviving on rations of you
Living on sporadic moments of feeding
Existing with the weight of memories
You are not to be held.

Clouds gathered like child soldiers
Their hollow, barely grey threats
A vain attempt to contain
You bowled straight through them
Sending delusion and premature bravery scattering for miles
To hide behind mountains
Flee out to sea
Their infant rumbles lost upon sweeping winds
You are too big for this world.

Mountains to oceans heed your command
Washed up lovers bury themselves in sand
And a rebel heart which bled so true
Tortured and lonesome amongst a thousand
Memories of you.

LEAVE ME

I want my skin to cry for sunlight
My hair, to miss the wind
Let my voice obey the silence
Calm the storm within.

I don't want to do anything!
I don't want to make them see
Through my eyes, our world
Just leave me be!

I don't want to praise the moon!
Or pray for stopped time
Don't want to count syllables
Or make my lines rhyme.

I won't tell them that Romeo and Juliet
Took the easy way out
I won't tell them
Let them figure it out!

WOE

He has made a stutterer of me
Pledging love upon every short breath.

I would that my tears, unseen, were red wine
Rather than my heavens rain
But, not upon his desert.

He will never know
How many angels wept...

Nonbeliever.

FILTH

I am a savage.

I am ancient grudge restless beneath pages of history
I am the mother who ate her own child
In God's image, still, I desecrate the holy
I am filth, dressed in silk robes.
I spit in the face of the polite
Gnash my teeth to drown out birdsong
I set fire to gardens of Spring
Loot houses for signs of a home.
I am a savage.
I curse the moon and all her stars
Drag them down, stomp them underfoot in the streets
I steal fire from the sun to stare down my foes
Laugh as they tremble like children and fold.
I ripped out my own heart to shred into tiny morsels
Fed it to swine then bathed in its blood
I tore off his wings, threw him from the edge of the world...

I am a savage.
So was he.

FURY

The mountain sleeps
Seemingly dormant, however
Restlessness stirs...

The world shakes, and earth shatters
Spews forth toxic matter
Pain takes form - a winged beast
Fire-breathing with a life all its own
In a burst of flaming rage, it ascends out of sight
Blacking out the sun, then, plunges
Darkness befalls the world
Many a Pompeii will be buried here
Once a reluctant parent to infant anger, now
A proud master; I watch on
This is my pain in all its majesty
Unable to control or prevent the ruination
Perhaps not wanting to
Every breath he takes to speak, I torch
Words fail
Smoke lifts, scorched earth
The dragon circles above

Carnage
A lone heartbeat quiets to a hum
Beneath ash, barely alive
Dying to survive
My fire.

L'ABSINTHE

I don't know what you gave me
When you took away your love, but
I am gone.

Breaking earth, I spiral downward
Beneath old empires of fallen kings
Past false deities, down through
All the fossilised Ages, the archaic trails of
Perpetual defeat. How is it possible
I am still falling?

I am not alone; I am haunted
Fleshless, you're multiplied, and
I am overcome
Degas, he painted a woman
Like me
She hangs in the Musee d'Orsay
You, your mock alchemy overdosed
Me and swept me into this affray.
I'm not your friend
You've poisoned pureblood

Neon profanity
I burn alive
In repetition...
Consumed slowly
Languished cries, swallowed
Never reaching deaf ears.

How could you dim the light from behind my eyes?
I am gone
And, I am gone.

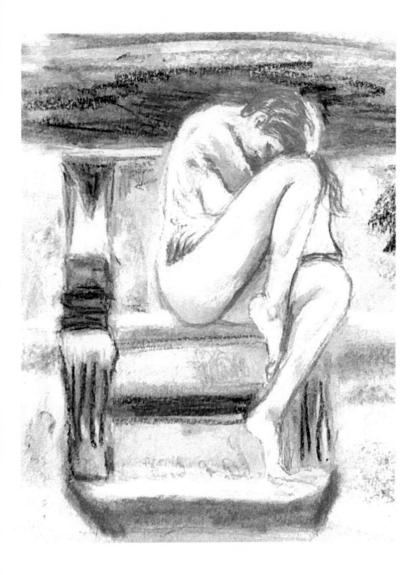

MEASURES

The same sun which kisses the slumbering petals, blanketed in
dew
You had me believe would burn me.
Heights I climbed, set my banner flapping in thinnest air, with
the breath of my own lungs
You said was time wasted ascending ant hills.
All the doors I knocked upon, picked locks, unhinged
Walked through, so I could smell the rain
You claimed would never open unto me again.
All the fruits of the forest, food from the earth
Grown in abundance by nature, to sate hunger
Sharing one mouthful, then devouring your plate
For feeding me, though a morsel
I regarded you with benevolence.

All the love I had to give - lost
Twenty thousand leagues under
Within myth, within fables, written by
Foolish minds long since passed

All, so you could keep me not.

BLASPHEMY

Once
And I would have followed you
Beyond the ends of the Earth
Until the end of time.

Nonbeliever.
I made you holy
Still, me you denied.

Even the skeptic, godless
Await the Second Coming.
I asked for a mustard seed.

If you only believed.

PARVENU

Cheap imitations of romance fill your daydreams
You haven't any business in the realm of poets
Where nighttime is the window to dreams
Place of romance, born of the stars
Which you shall never reach
Nor ever claim.

Stop throwing breadcrumbs
Upon which I no longer feed
I tore through forged iron
To feast on the young of obedience
I have taken flight
I shan't go back to starving

For you.

UNA FURIA

You are a lesser star
Kissing the horizon with poisonous lips
Polluting the night with artificial radiance
I have awoken, you are none but falsity.

My Sun is a jealous one
His wrath you should fear
Go, retreat, whence you came
In my folly, I let you near.

Verity, you shun as the light of day
Come no more into my dreams
Weak and pale, fool me none
I am done with thee.

EDIT

I rewired your static heart
Set it to music.
I reworked your defiled body
Made it sacred once more.
I rewrote your tattered history
Corrected your false tales of love.

I reset you.

All but your scrambled mind
Which lagged behind
For too long.

Now, try living top-down.

SENSES

One wreaks havoc like the wind
The other lives to inspire

One's a beacon

One's wildfire.

FOOL

I seek the silence
Inside the silence
Its shriek of loneliness.

I cannot bear it.
Flesh, numb.
Throat, choked.
Eyes, burn; the sting of one thousand whips.
My feet, without direction
Having no ground
Know not where to go, now that they don't follow.

My heart, what shall we do?
Your silence, too
Deafens the fool who bowed to you.

HAUNT ME

Ivy, her greedy tendrils clutch you
Rain floods your burning soul
The wind howls to scare the dark itself
Until your cracks appear to expel
Your pain.

I shall wait for you
Until the sun returns and we shall
Live again.

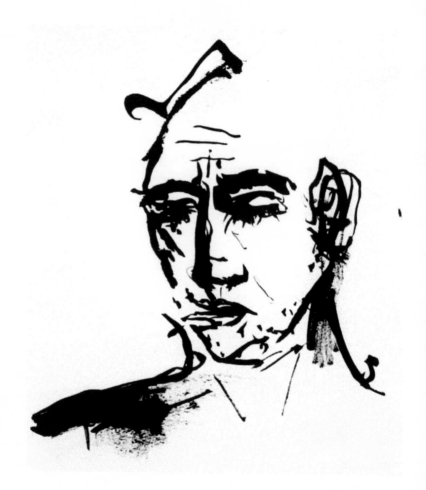

DEAFENING SILENCE

My heart screams as
Dreams scatter.
Like wild and violent oceans
Observed from the portholes of a battered ship
Eyes, the only window from which to see the storm raging
within.

If you should notice
The frenzy behind the pane
Do not ask
Lest I blink a torrent and drown in
My sorrow.

SPILLED INK

I hear neither birds nor leaves, no thunder
No roar of the sea
Now that my world has gone back to mute.

Like a painter in darkness, tools dormant, without light
All is dull; I am colourblind.

Famished, this body without yours.

The silk of your scarf, abandoned, mourns your scent
Memories, hushed, never again to warm my heart.

No more shall my gaze find your face
No song shall enter my state
Still, I will always write for you.

BEING

I have traded one god for another
Earthly love for unearthly love, my truth.
And, all I do now, whilst I stare down time
(I do for him)

Lips move in silent prayer, even in sleep
Now, that he has, too soon, moved on from here
Left me to live on land where love is lost.

NEWTON'S THEORY

Flesh and love matter is sent hurtling for miles
The river Nile, red, bursts, floods the Earth.
A plague of pain silences Man
Beneath darkness that knows no sun.

STRANGLE

What of rules?
How tightly they bind
I hate their stranglehold on life.
No more.

No more rules.

Iron, inked on paper
Whose rusted sentences are chains
And lifelong.
Sound of shackles a vocal shadow
All these years...

Now, freed by the noon sun shall I
ascend.
May they be blinded, twice -
Sight, as are their souls.

GRASP

Before having a chance to digest all
I had been fed
Deceptively
By way of a silver spoon
They attack my mindset.

Allow me to savour the toxin
So I may remember its burn
Pseudo rapture...

Then, watch as
I expel with mastery
My gullibility.
Not a footprint shall mark -
So slight of foot
I hightail it away
To join the ranks of the sullied
Meandering through a world of
Polished hypocrites.

GREEN

Saliva glistens, the air you suck
Through your teeth
Greedy
Awaiting the stroke of luck
As a maggot feeds on a carcass
You devour all life from life.

Which hand of nature will serve the need
To remove my foe?
Ill willed and covetous as a miser's greed
And patient as a sloth
Shall winds, fire, sea or quake remove?

Lustful, you pursue scent on the air
And the vulture waits his turn
Maimed, broken of spirit, without a prayer
Of having refuge and warmth
As you circle my scented air.

Violent seas drown hope; the lighthouse
Mourns in black. Clouds smother moonlight

Widow's grief at the death of her spouse
How shall one reach land?
Clouds hide the moon as she weeps.

TRASH

Beware of vultures
Swooping in to devour live prey.
They do not care that an injured heart still beats
Or that wounds may heal
That the blood they inhale is replenished
So long as the heart may beat.

Just as the sun sets only to rise again
At the very least
Even in seeming death
Love should be respected.

SALT

The one who strikes another down
Sees not the lightning born behind the eyes of the fallen
Feels not the storm gathering beneath beaten flesh
Hears not the thunder roar inside the mind...

My, how the fallen are mighty.

UNKNOWN

If I cease to write of love
Who will I become?
I thought I'd write about the trees
Until I remembered how their leaves yearn for the breeze.
So, I tried to write about the hills
Whose flowers bloom with the kiss of dawn.
Then, I thought to write of the seas
Until salty tears fell as I recalled the
Weeks since I last saw him...
What shall I write of where he is not?

NOSTALGIA

Nostalgia roams memory lanes
Passenger door open, driving
One way
Into sunset...

You are none more wistful than
The blind person
Who once could see.

BIG CITY

You traded in bare feet, for shoes
To walk perfect city gardens of hedges
Grown in perfect little rows. Of tulips
Arranged in differing heights, colours.
Of trimmed rose bushes, and to marvel at
Repetitive topiaries
Tamed, made common, in the name of Art.
Unnatural order, disguising man's
Imperfection.

I shan't try to convince you of a beauty you never saw
May never see
Now that you've been scared back into conformity.

You found yourself
Lost, barefoot
In the unfamiliar
Where trees part for sunlight
Where untamed shrub shelter secrets
Where ivy reigns supreme, unashamedly
Hungry tendrils greedily embrace anothers.

Where calm streams sing lullabies
Wild flowers grow in shade.

How could you know a love like that?
You tread upon concrete
Hiding your feet from raw earth
You'll never feel the ground
You'll forget her stony paths
You'll shelter beneath umbrellas
Forgetting the tree hollow
You'll dance to music
Drowning out the call of wind rustled leaves
And live a life of contentment...

Not of bliss.

THE TRAGICS

This heart, without strength to mend the hurt
Watches the scene:
A dimly-lit vessel
Heart at half-mast
No wind beneath its claim.

Who shall love you?
How shall it be?
When all I am
Fills every part of thee.

DISCARD

Light your candle, make a wish
Upon a breath, you stole
May its light shine enough to guide your way
Back home.

Darkness, you bury yourself beneath
Life's deceptions
And you're cold
Your heart murmur
Saddens the only soul to ever hear yours.

It keeps burning, for you
Though torn, cast away
A lone flame, surviving a blizzard
In your name.

KINTSUGI

Let them curse it that cursed love
May their impassioned cries comfort my pain
Thunder silence my storm to quiet rain.

Delving into the darkest black to follow
Him
I searched every corner of an elliptical sub-world
Amongst shipwrecks, skeletons, ghosts and treasures
I ran out of breath to surface...

And, then,
There
Was God
With one more breath for me.

LETTING GO

Naught consoles me.
Tears flood my eyes and burst the banks of my strength. I smile
So shallow I may not be smiling at all
A soldiers armour protecting his corpse.

He has gone, away. Naught consoles me.
The sun has dimmed and the north wind slashes at my face
Love harms none, people harm people.
I must
Be like the reed, pliant
For the mighty oak was uprooted and thrown
During the storm. Bend

This, too, shall pass.

ORIGIN

There is no tempest more powerful
Leaving no more deafening silence
No place more entirely devoid of matter
Than the one which comes in the wake
Of the sudden removal of affection.

Only when you have been reduced
When silence claims the barren desert of your mind
When you come to know peace in solitude
Then

Like unsuspecting game
To vulturous birds of prey
With one swoop you shall be lifted
Though, not a talon shall draw your blood
For you were lost
And now are found
And you shall be carried upon the
Winds of change.

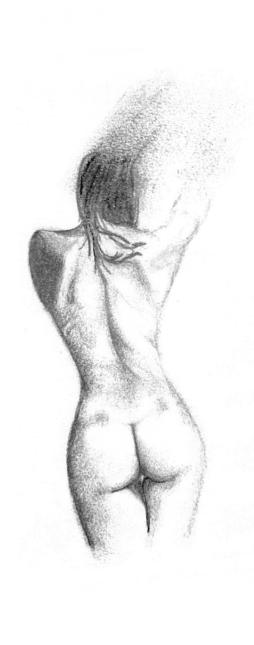

IF EVER

No green of Earth, no breeze nor song of waves
Violent storms mocking form, a thrown leaf
Angry, resenting your own affliction
Desperate to contain such grief.

You ask the Fates how you came to be here
Upon throne of love, respect, once was crowned
To have loved, lost, and dared to love again
Barely healed, once more you're struck down.

If ever again you doubt the heavens
If ever your own sacred heart you curse
If ever you question your life's purpose
Heed the doctrine of Mother Earth.

Across the skies cracks of thunder, fury
Echoes in your mind to arrest your doubt
Summoned from depths the sea she heaves and roars
Further, smiting your curse, she shouts:

Upon you sends forth violent torrent
Scorching heat, feet of snow, her sleight of hand
So never more you question your reason
You've been chosen, though sad, now stand.

You were meant to fall, you were meant to lose
You were meant to shatter and wake the Earth
Your breast lay weary upon hallowed ground
Deep tremors, heart beat, jolts rebirth.

One hand clutches the heart, guides from ruin
As army strong, though come not to defeat
Molested with ache of a thousand souls
Bless'd strong, solid ground stay your feet.

Breath of Heaven and of Earth fill your lungs
Tend those needing of your strength, downtrodden
Carrying spirit strong of past Ages
You, to them, a queen dressed common.

WITHOUT

Once overflowing, she now marvels at the
Weighted emptiness.

How beautiful
Deep grooves of cupped palms
How sacred
Walls of a hollowed heart
How clear
Eyes free from tears
How brave
Fallen face in its attempt to smile.

As the barren desert feeds the soul
Like the lost in the wild builds resolve
Without rain, without direction
She is nourished
She is found.

FORMULA

And how is it shameful and
Why would you feel the need
To lie about your shortcomings and defeat to even
Your own precious children?
Who will learn many lessons by watching you fall, and
Come to know many secrets by
The way you rise.

MISER

You sit in your castle, I'll sit in mine
Weigh your gold, polish my dime.
Seek your merriment, I'll live my bliss
Without your judgment, which shan't be missed.

You'll see the world, though, not as I do
You'll climb the highest towers, still
I'll see more than you.

LION

Look at that!
The sky did not fall
The moon still shone
The oceans roared, sounding
Your courage
To remind you
Although you may be removed from the jungle
You are still mighty enough to rise above
The weighted silence of your sunken wrecks.

APERTURE

The sun still rose, the night still fell
The birds still sang, waters still ran
But for one moment, earth drew breath
The breeze withdrew, and I noticed.

At dawn I rose, at night I rested. Each
New day opened in promise, and my eyes
Smiled, but for one moment, hollow felt
Heart-stricken - my breath, so too, fled.

Seasons roll over, leaves green and redden
And fall. Silver grows in Autumn's beard
Time cedes wisdom, furrows keep pace
But for a moment, time stands still...

My mind finds him in the Spring
I remember that
One moment within
A fleeting lifetime
When my soul
Seen, smiled and swelled into myself.

SONATA

Though removed
Though silent
Once, they played.

Now, she plays their piece solo
For if she is mute
He is nowhere.

Raw love fears neither ridicule
Nor rejection. It is the closest
A heart can get
To divine feasting.
It is there
Love plays its sonata
Forever.

ONE FOOT IN HEAVEN

Silence became birdsong
Heavy hearts, grew wings
Dreams so real, we knew not which life we belonged to.
Hope fanned by winds of change
Love so pure, we bottled its essence
Pain so majestic, others envied the depths.

Our world took my soul.

HIGHER LEARNING

At the edge of the world, there's a city
And at the fringe of its chaos
A University
Within whose walls are a playing field
That sleeps with the dying sun of the day.

I rested my head upon his chest
Music played upon the breeze
And soon we slept a midsummer night's dream...
We woke with a stretch
Fifty cats did the same
Sensual purrs and movement of limbs
A dreamlike state, awake.

Car horns sounded outside the stone walls
That could not keep them out
Polluting seaside calm
And the time that had stood still
The held breath of a weary moon.

Oceans and months apart
Yet, still, I am in your arms
On the green, green grass of July.

THE OTHER SIDE

I stand in a place I once feared
I'll sign my name in its sand
Then, onwards
To where the wild things are.

I fear none
I fear I lost the know-how
And it is the freedom I once craved.

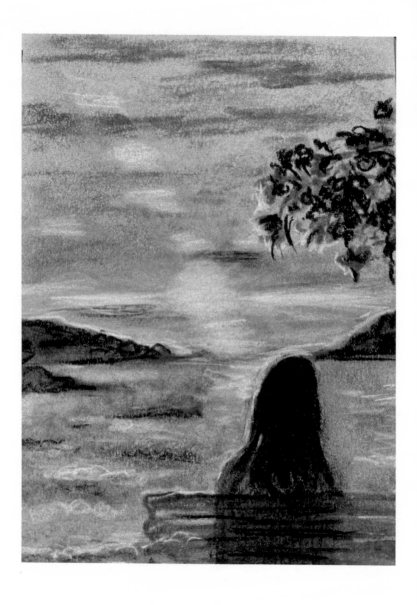

A LIFE AT SEA

I've no need of the shore
I am found at sea
One with the ocean, whom
From my tears
Takes her fill.

Beneath the surface emotions peak
Grief, in waves so astounding, crashes into
Howling winds, my roar
Thunderous
Drowns out their cries.
The depths are rattled
The buried below, release
Startled ghosts that cower
Haunted themselves.

Fated to roam the seas
I've no need of the shore
I cannot go back
I've no need of the shore
It would only lead to you.

TEMPTATION

I would not for all the world
Go back to yesterday
My soul, now, beams, glows
In the light of its own sun.

LADY SKY

Every day, I wait for the pink sky
Which only this year, as Autumn neared Winter, I noticed.

Fiery leaves on Birches, that will
Fall any day now
Release their colour to the sky, as if
A final breath
As the sun sets upon their season.

And, suddenly, pink is my new favourite colour.

MY WEALTH

It's all in the eyes. All the words I cannot say, all the words I've never heard, vacant eyes which once captivated, all the feelings without a name. All the sorrow...

My father's eyes, cedar green, sometimes with hazel sfumato, unique; they've never fooled me. By which old duel were the words of his heart banished from his voice? Though his mouth spoke not of love, his eyes betrayed him. I was thirty, I crossed the room and felt a pull from my peripheral vision. I glanced left and back, shot my eyes left again; the look in those green eyes was a thousand and one stories of love. Bedtime stories, finally. My feet betraying me, I could only stand and smile at his smile, then I turned and walked as though on air. It was one of the most beautiful stories I've read.

I am wealthy. My riches: six cognac-brown coloured gems of the rarest kind. Wherever I am, they seek me. Whenever they are lost, I find them. Whenever they drown, I lift them. They sparkle as the stars of night; they are as deep as her universe. I may read the words of scholars and poets, yet, those brown eyes have taught me more than my beloved books. I always wanted

my father's green eyes, until I met these three children who call me mother. The way our eyes dance this little dance we have perfected, darting from one pair of eyes to the next and back again, fills my soul with music and an ancient consciousness of the most natural form of expression.

I had never known my worth, there are times I doubt myself still. Yet, within those backlit brown eyes, brown as the bark of the cedar, I feel I am loved as though from the beginning of time; so deep are the windows to their old souls, so alive within their beautiful young bodies. Ask me, a lover of words, my favourite story, and I shall tell you it's the ever-giving tale of the soul which I read through six brown eyes.

- Excerpt from a personal essay, Paris, 2016.

Afterword

This collection of works began many years ago without the intention to ever publish. As my life journey took me, and often nudged me toward many paths that my cultural and religious conditioning did not necessarily allow, I found freedom in writing and it soon became a vital outlet of expression. When one is not heard the voice will find a way; this is my song, these are my words.

Find yourself in everything. If you let yourself be yourself, you won't need to look far. Be wild. Be strange. Be free. Be curious and brave. Those who never had the courage to climb the mountain, let alone venture beyond their borders, know not what you know, and fear the unknown. None would return having seen the way the sun and moon shine on the other side of fear.

Dany M Hatem.

Acknowledgements

My grateful appreciation to my dear childhood friend and artist, Leana Regina, and to the talented painter and sculptor, Carmonn French. I could not hope for more fitting artworks as a companion to my words.

Both women possess a deep, raw, and honest passion for life, an understanding of one's undulating journey within it, and the rare capability to transfer this to a visual form breathtaking to behold. Each of Carmonn's faces draws the reader in; they are intimate poems all on their own. Leana's figures and compositions likewise saturate the viewer with pure emotion, striking to the core of what it is to be alive in this world, just as you are.

My deepest respect and love goes to my cousin, Sabel, my strength and defender, for her unwavering belief in me and for fanning the little spark I had left inside.

Artworks:
Cover art, nudes, landscape and hands: by Leana Regina. Used with permission.
Faces: by Carmonn French. Used with permission.